Africa 2006 - 2007

Julee -

This will be the begining of a new chapter in your life! You are going to make such a great life for yourself... :) You inspire me!

Love!
Aimee

Follow Your Desire

Images to Words

Photography by Victor Gagliardi

Gagliardi Photo Collection
New York
2006

Gagliardi Photo Collection
39 Hudson Avenue
Nyack, NY 10960
845.358.7031
www.gagliardiphoto.com

© 2006 Gagliardi Photo Collection. All rights reserved.
Printed April, 2006

Library of Congress Catalog Card Number: 2006901797
ISBN: 0-9712687-6-2

Book designed by Peter Lukic
Printed by Editoriale Bortolazzi-Stei s.r.l., Verona, Italy

Cover photo: *Afternoon*

"Follow Your Desires" was compiled for young adults from eight to eighty to remind both them and myself that what helps to keep us young is following what we love. I collected these writings over a period of twenty years from people whose words resonated within me. The photographs are there to support the writings, and not the reverse.

Many of these images and passages come from my first book, "A Turning Point – Images to Words." It was first released in 2001 and is now in its' fourth printing. "A Turning Point" has been carried by over 1400 independent stores in eight countries. These books reflect the process I went through in order to be able to do the work I love.

I began capturing images in 1977 and fell in love with my new hobby. In 1989 I sold my first photographs as artwork and two years later left my career in business to work full-time as a photographic artist. I currently own a gallery in Nyack, New York.

This book is dedicated to my dear friend Ballie King who passed away at 100 years old. Ballie lived her life fully, followed her desires, and always said "I've been, where you gots to go."

<div align="right">Victor Gagliardi</div>

Follow your desire as long as you live;
do not lessen the time of following desire,
for the wasting of time is an abomination to the spirit.

—Ptahhotpe 2350 B.C.

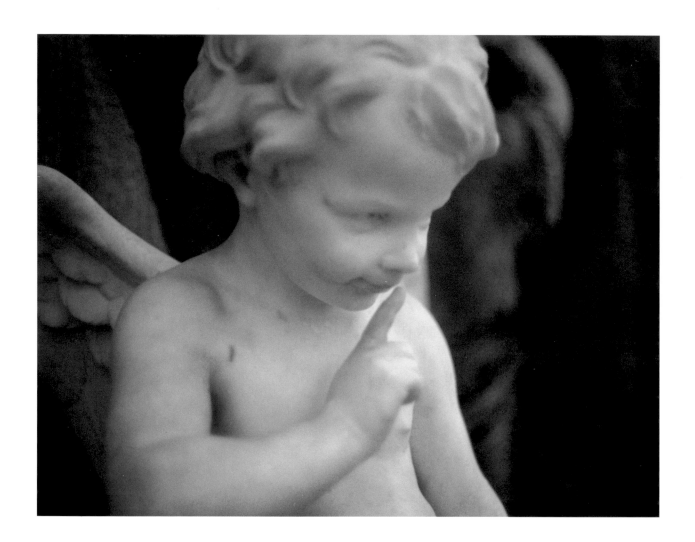

Cherub of the Louvre

It is said, and it is true, that just before we are born
a cavern angel puts his finger to our lips and says,
"Hush, don't tell what you know."
This is why we are born with a cleft on our upper lips
and remembering nothing of where we came from.

—Roderick MacLeish

And do not change.
Do not divert your love from visible things.
But go on loving what is good, simple and ordinary;
animals and things and flowers,
and keep the balance true.

—Rainer Maria Rilke

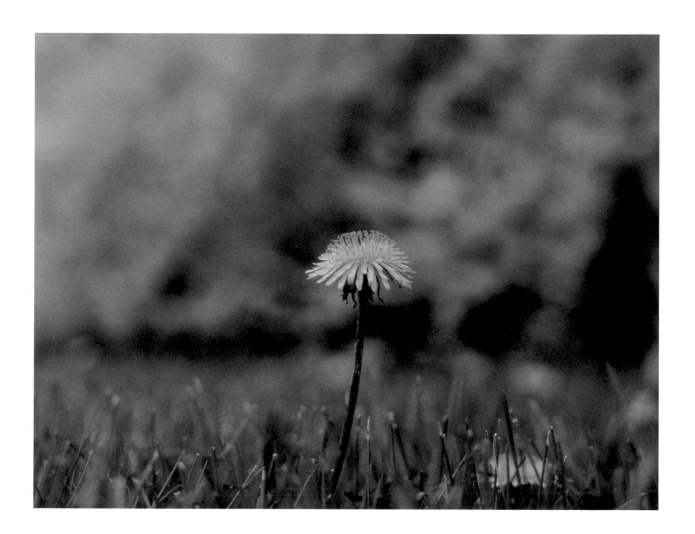

Dandelion

...Merrily, merrily,

merrily, merrily,

Life is but

a dream.

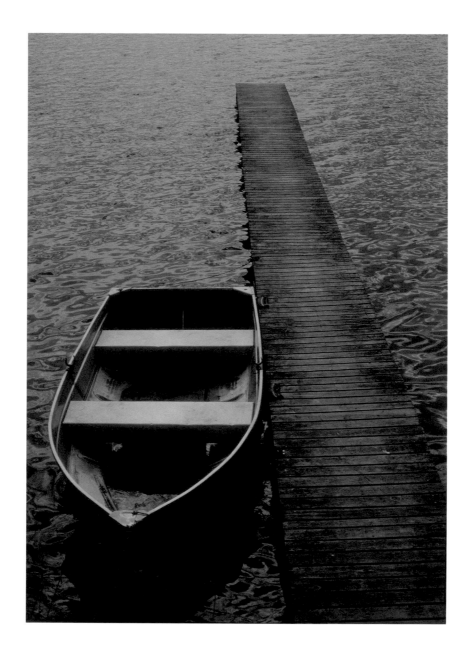

Rowboat

When I was young, every day
was as a beginning of some new thing,
and every evening ended
with a glow of the next day's dawn.

—Eskimo poem

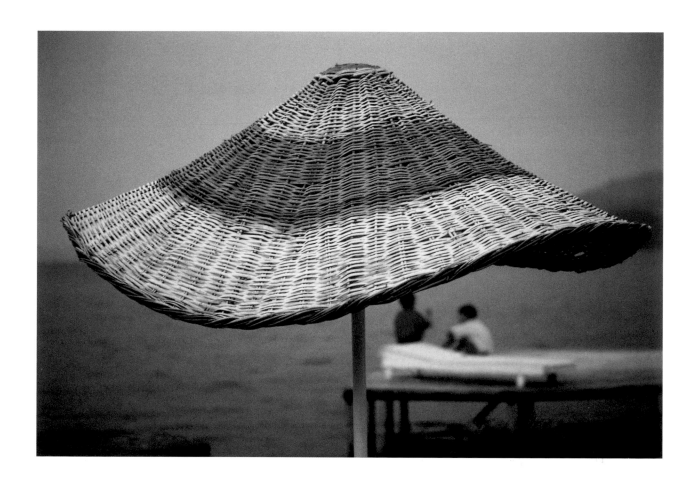

Meeting in Bodrum #3

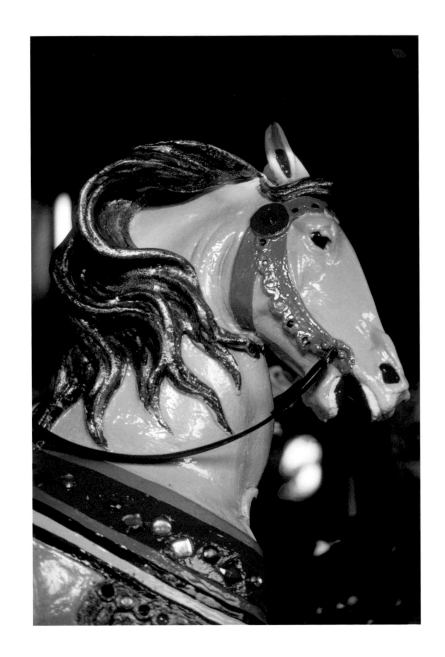

Carousel Horse #6

If I had my life to live over,
I would start barefoot earlier in the spring
and stay that way later in the fall.
I would go to more dances.
I would ride more merry-go-rounds.
I would pick more daisies.

—Nadine Stair

The moment one gives
close attention to anything,
even a blade of grass
becomes a mysterious, awesome,
indescribably magnificent world in itself.

—Henry Miller

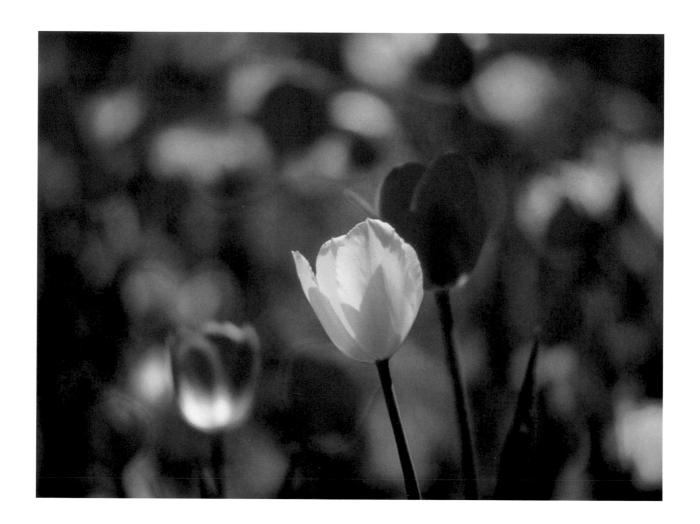

Tulips Together

I am always searching for peace,
but it is the forest fire that forces open the pinecones
that allows for new trees to grow.

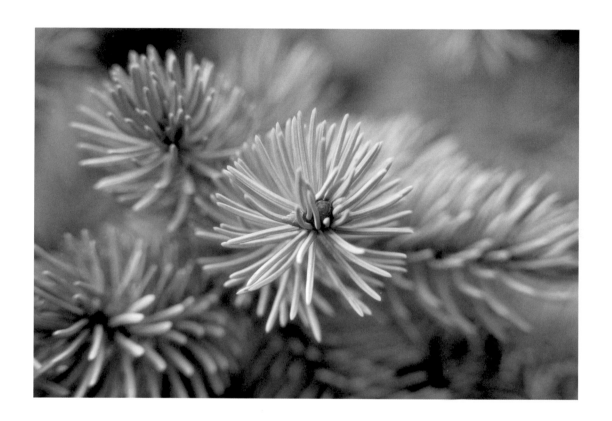

Blue Spruce

I suddenly thought,
"Well, what did you think it was
that needed to be loved?"
And just like that, the doors opened
and I was in paradise.

—Thaddeus Golas

Palms #2

Every life has a measure of sorrow.
Sometimes it is this that awakens us.

—Jack Kornfield

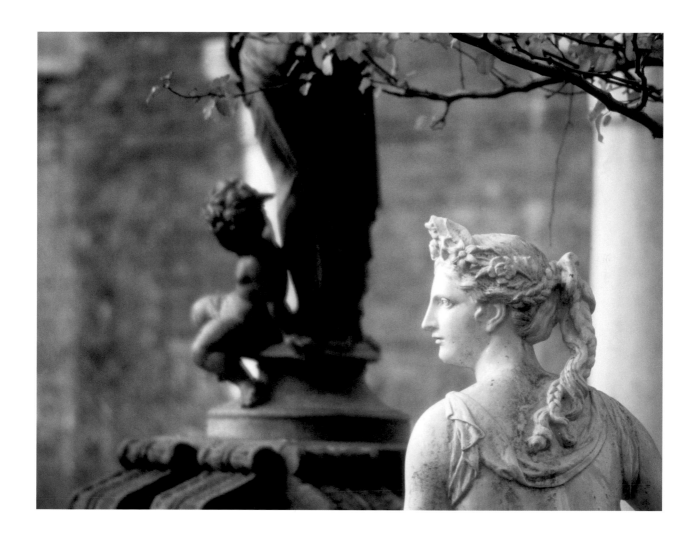

Single Woman

And here is my secret, a very simple secret.

It is only with the heart that one can see rightly;

what is essential is invisible to the eye.

—Antoine De Saint-Exupery

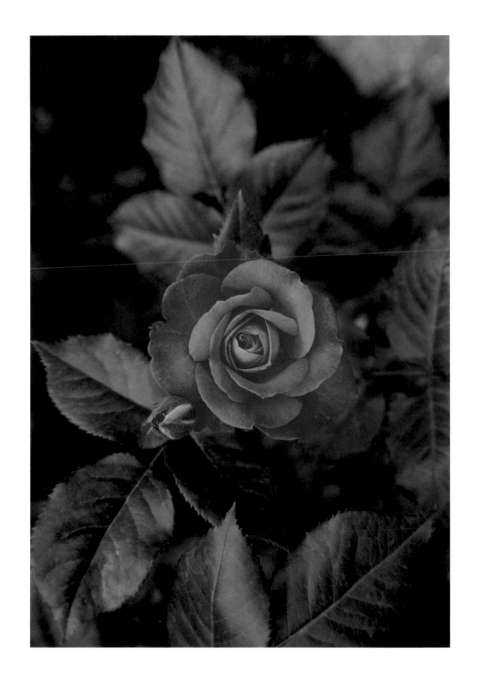

Antique Rose

What makes a saint?

Why were the saints saints?

Because they were cheerful

> *when it was difficult to be cheerful.*

Because they were patient

> *when it was difficult to be patient.*

Because they pushed on

> *when they wanted to stand still.*

And kept silent

> *when they wanted to talk.*

Were agreeable

> *when they wanted to be disagreeable.*

That was all.

It was quite simple,

> *and always will be.*

—Mirian C. Hunter

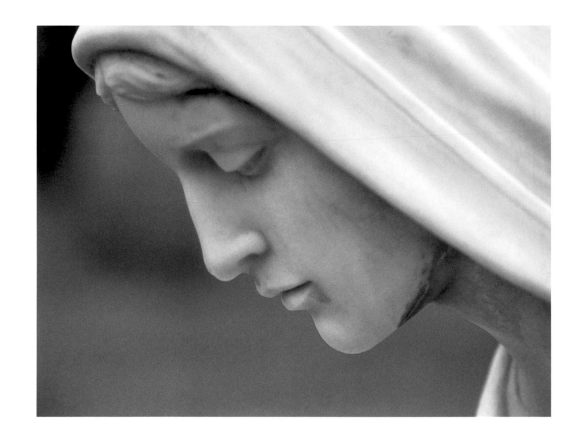

Mary

It may be true that he travels
farthest who travels alone;
but the goal thus reached
is not worth reaching.

—T. Roosevelt

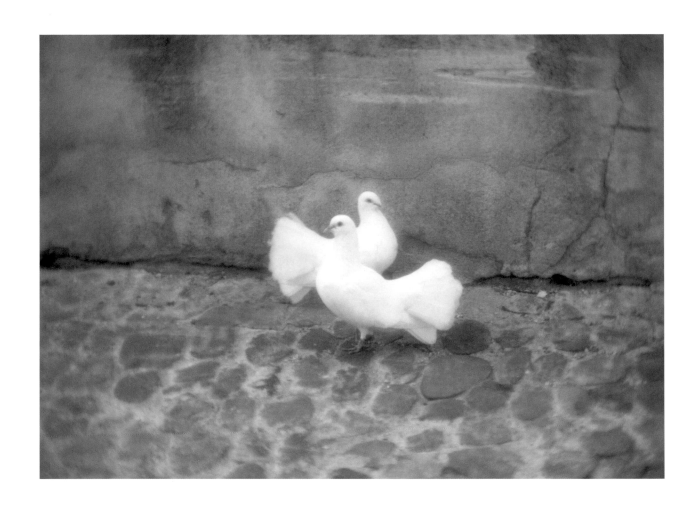

Two Doves, Avignon, France

As a man's real power grows and his knowledge widens,

ever the way he can follow grows narrower:

Until at last he chooses nothing,

but does only and wholly

what he must do.

—Ursula K. Le Guin

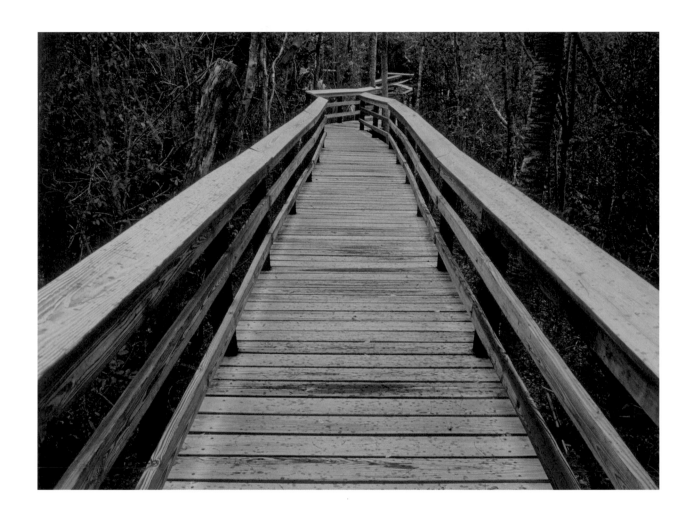

Walkway

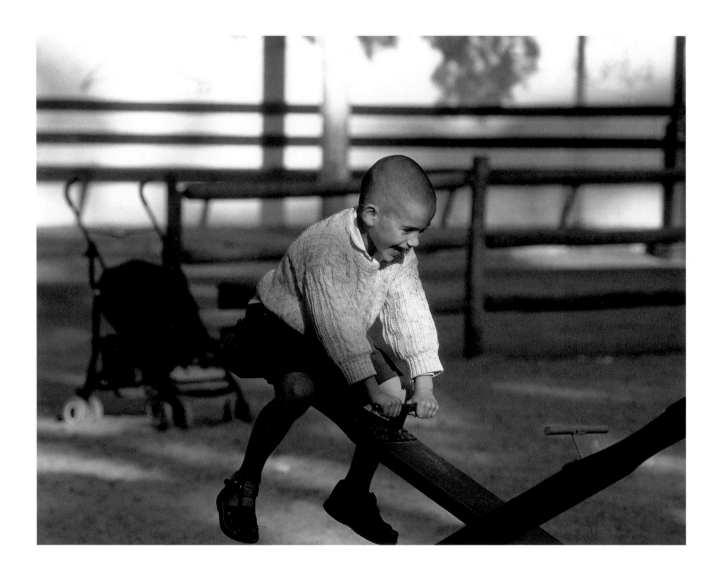

Seesaw

A man does not learn to understand anything

unless he loves it.

—Goethe

Security is mostly a superstition.
It does not exist in nature, nor do the
children of men as a whole experience it.
Avoiding danger is no safer in the
long run than outright exposure.

—Helen Keller

Family of Mushrooms

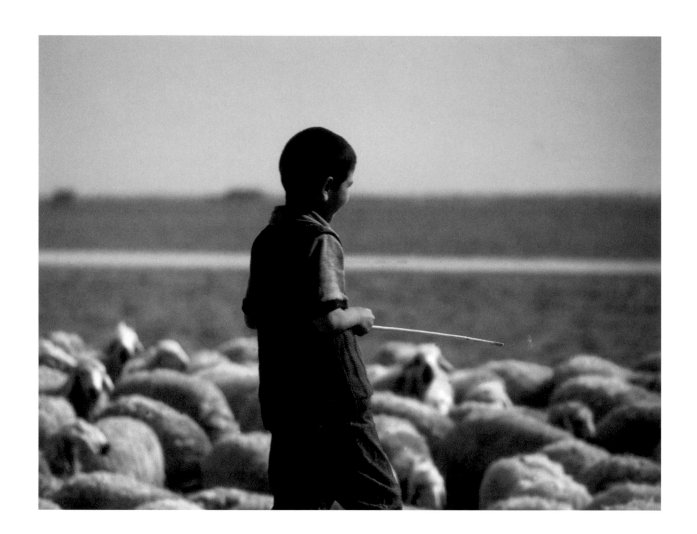

Little Shepherd

*And to love life through labour is to be intimate
with life's inmost secret...And when you work with love
you bind yourself to yourself, and to one another...*

—Kahlil Gibran

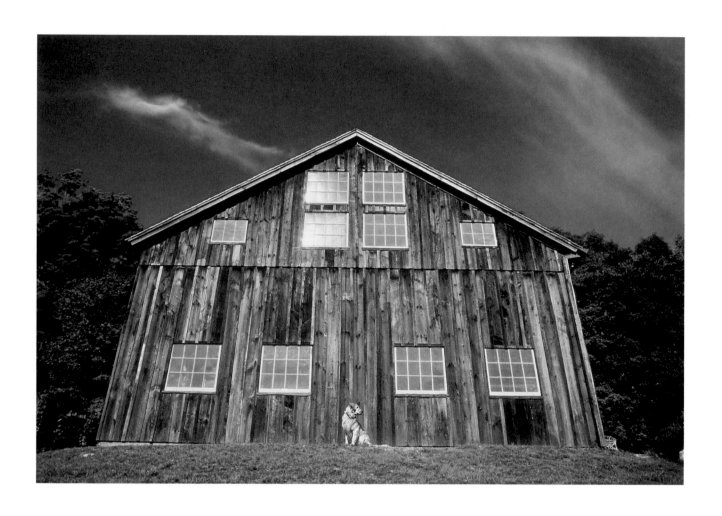

Jezebel's Barn

I said in my heart,

"I am sick of four walls and a ceiling.

I have need of the sky.

I have business with the grass."

—Richard Hovey

I had to go. It was my last chance to be a boy.

—T. Roosevelt

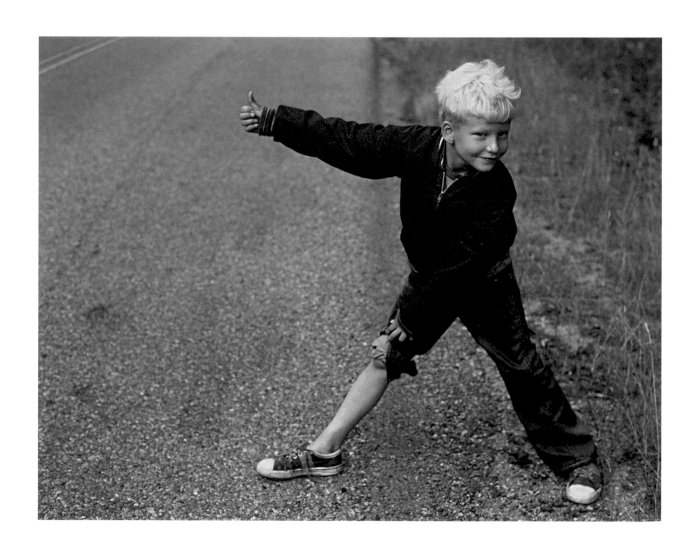

Trevor

In dwelling, live close to the ground.

In thinking, keep to the simple.

In conflict, be fair and generous.

In governing, don't try to control.

In work, do what you enjoy.

In family life, be completely present.

—Tao Te Ching

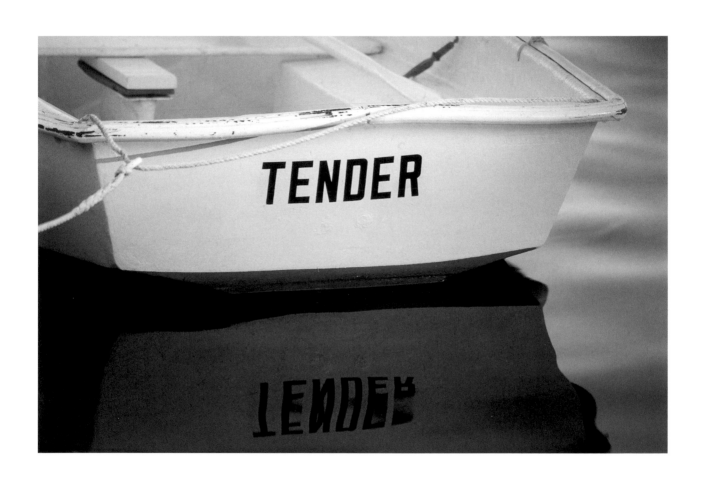

Good thoughts
will produce good actions.

—The Buddha

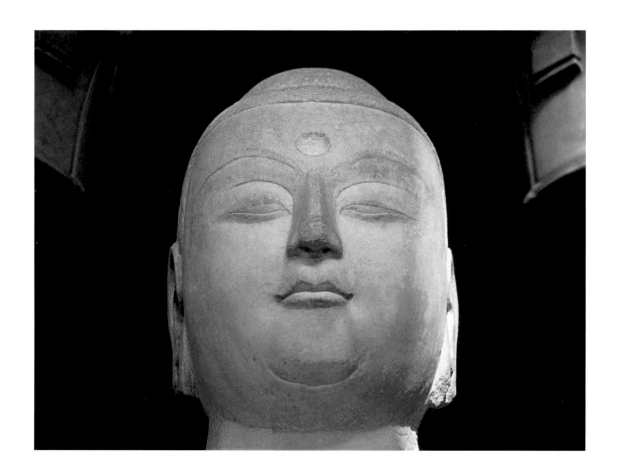

Eyhraune's Buddha

The tree which moves some to tears of joy is in the eyes
of others a green thing which stands in the way.
As a man is, so he sees.

—Blake

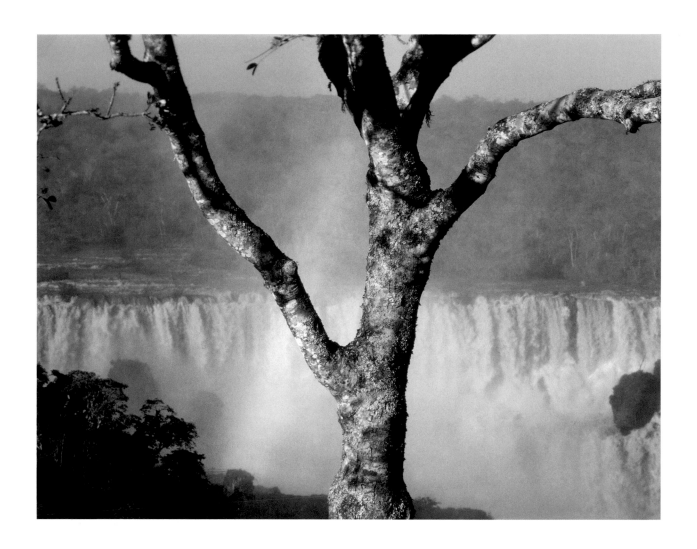

Rainbow Falls

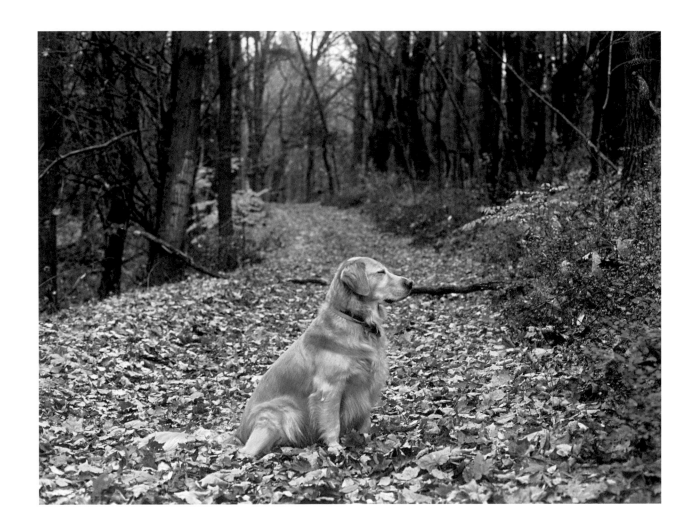

Meditating

You are sitting on the earth, and you realize that this earth deserves you and you deserve this earth.
You are there—fully, personally, genuinely.

—Chogyum Trungpa

Great spirits have always encountered
violent opposition from mediocre minds.

—Albert Einstein

Einstein

One person with courage makes a majority.

—Andrew Jackson

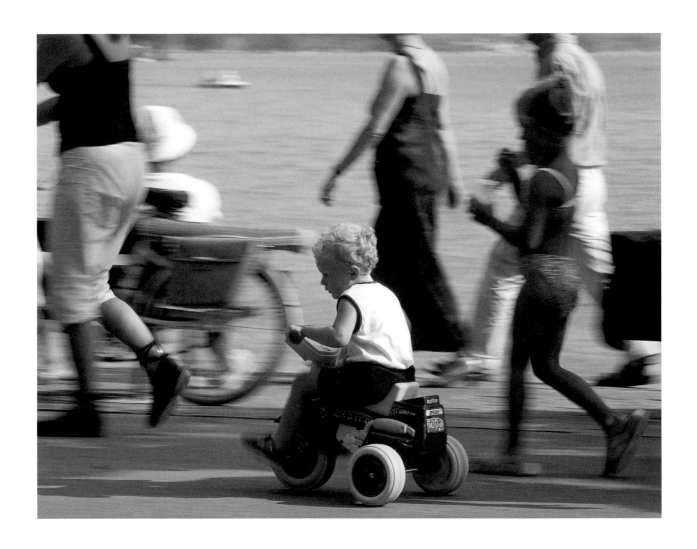

Driven

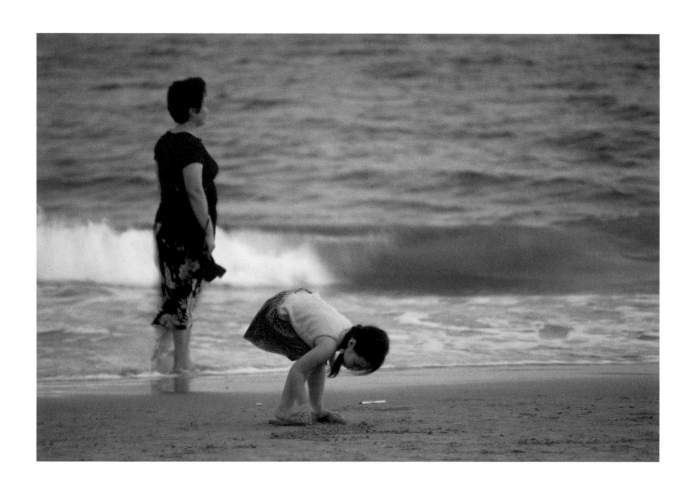

Miles Away

Even if our efforts of attention

seem for years to be producing no results,

one day a light that is in exact proportion to them will flood the soul.

—Simon Weil

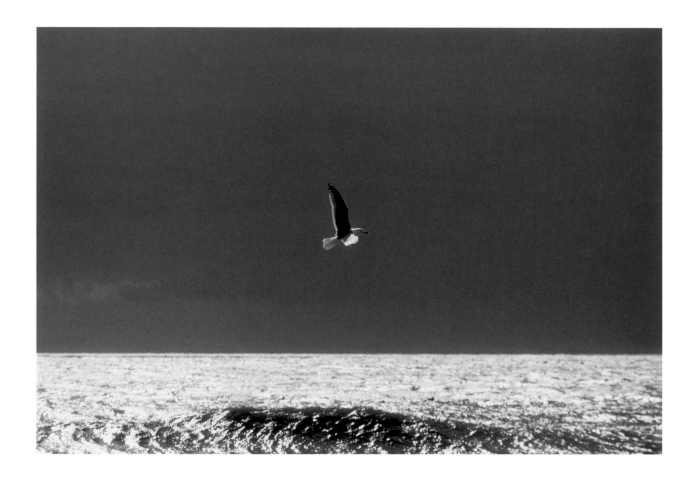

Wings & Waves

Look forward, continue to grow.
As long as you live you have a future.

—Boyd

If you bring forth what is within you,

what you bring forth will save you.

If you do not bring forth what is within you,

what you do not bring forth will destroy you.

—Jesus, from *The Gnostic Gospels*

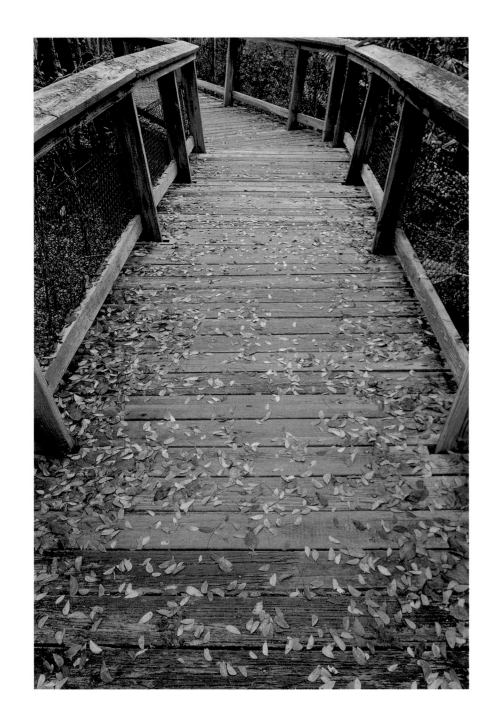

Walkway #3

...bringing forth wings and feathers like angels;

After that, soaring higher than angels—

What you cannot imagine,

I shall become that.

—Jelaluddin Rumi,

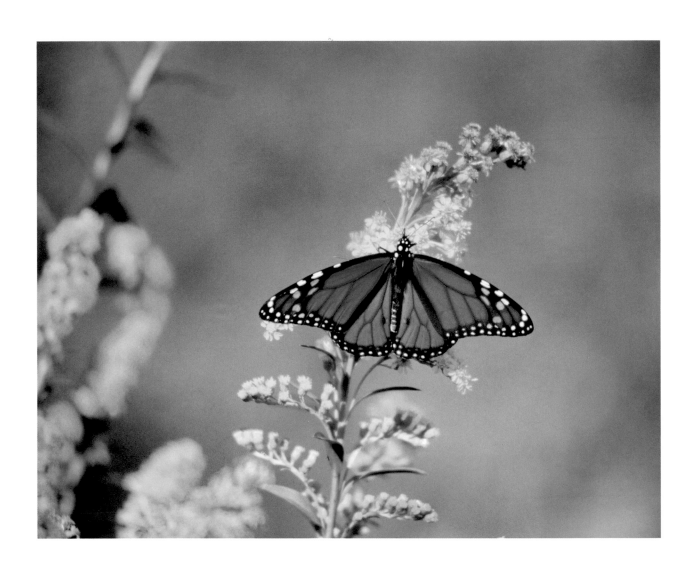

There is a vitality, a life force, a quickening that is translated

through you into action, and because there is only one of you in

all time, this expression is unique. And if you block it, it will

never exist through any other medium, and be lost.

The world will not have it.

It is not your business to determine how good it is,

nor how valuable it is, nor how it compares with other expressions.

It is your business to keep it yours, clearly and directly, to keep the

channel open. You do not even have to believe in yourself or your work.

You have to keep open and aware directly to the urges that motivate you.

Keep the channels open.

No artist is pleased…there is no satisfaction whatever at any time.

There is only a queer, divine dissatisfaction: a blessed unrest

that keeps us marching and makes us more alive than the others.

—Martha Graham to Agnes DeMille

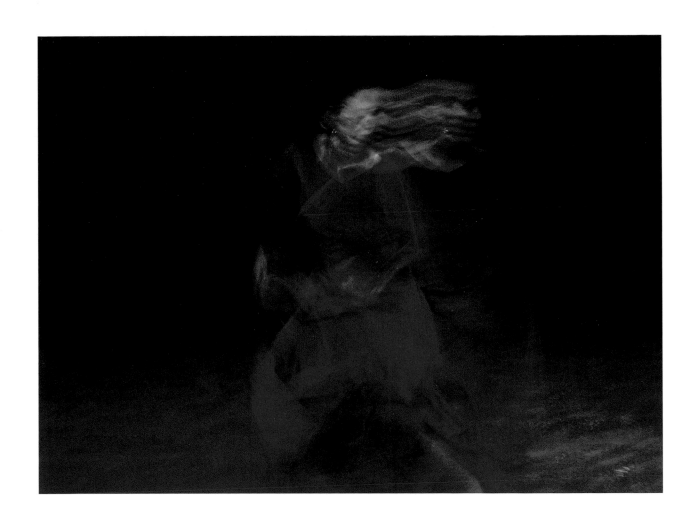

Desire

For permission to use copyrighted or protected material, we thank the following literary executors and publishers. We have made every effort to obtain permission to reprint material in this book and to publish proper acknowledgements. We regret any error or oversight.

MacLeish, Roderick. *Prince Ombra*. Reprinted by permission Congdon & Weed.

Rilke, Rainer Maria. *Letters To A Young Poet*. Translated by Stephen Mitchell. New York: Random House, Inc., 1984.

From *The Selected Poetry of Rainer Maria Rilke*, edited and translated by Stephen Mitchell. Copyright © 1982 by Stephen Mitchell. Reprinted by permission of Random House, Inc.

Stair, Nadine. "If I had my life to live over" from *If I had my life to live over I would pick more daisies*, ed. Sandra Haldeman Martz. Watsonville: Papier-Mache Press, 1992.

Golas, Thaddeus. *The Lazy Man's Guide to Enlightenment*. Palo Alto: Seed Center, 1971.

From *The Little Prince* by Antoine de Saint Exupery, translated by Katharine Woods. Copyright © 1943 by Harcourt, Brace, & World, Inc. Reprinted by permission of Harcourt, Brace & World Inc.

Le Guin, Ursula from the *Wizard of Earthsea*. Bantam Press, 1975.

Desire, photograph of Karim Noack, creator of the coreographic theatre performance, *Six Months to Live*. karimnoack.com